Darlington and Surroundings in Old Postcards

ARAF CHOHAN

Dedication

In every culture known to humanity mothers are the pinnicle of human relationships.

Reverence for mothers may have been greater in some cultures than in others but that reverence has always been a cornerstone of the human family throughout all of our collective recorded history.

It is therefore very easy for me to dedicate this book to my loving, caring and beautiful mother who in my eyes was the best and most wonderful in the world.

NAFEES AKTHER CHOHAN - June 11th 1931 - June 14th 2010

First Edition 2015
Published by Destinworld Publishing Ltd.
www.destinworld.com

British Library Cataloguing-in-Publication Data
A catalogue record for this book is available from the British Library.

ISBN 978 0 9930950 5 4

CONTENTS

INTRODUCTION

Darlington is an ancient market town yet it is also the product of a proud industrial past. With a history of global significance being at the forefront of the industrial revolution, Darlington also became the birthplace of the modern passenger railways.

With a long history stretching back to its founding during the Anglo-Saxon period when it was known as *Dearthington*, which seemingly meant 'the settlement of Deornoth's people', by Norman times the name had changed to Derlinton. During the 17th and 18th centuries the town was generally known by the name of Darnton but gradually the modern Darlington became commonplace. Darlington's market was established as early as 1183 and the Grade I listed St. Cuthbert's Church is one of the most important early English churches in the north of England. However, it is not the oldest church in the town, which happens to be St. Andrews's Church which was built around 1125 and is in the village of Haughton on the eastern edge of the town.

Daniel Defoe who visited Darlington in the 18th century noted that the town was eminent for "good bleaching of linen, so that I have known cloth brought from Scotland to be bleached here". Therefore, even before its fame as a railway town it had industries that were known far and wide. However it was the 19th century that truly put Darlington on the map as it transitioned into a rail hub and centre for manufacturing associated with the railways. Darlington owes much of this industrial and modern development to the influence of local Quaker families, especially during the Victorian era, and it is famous worldwide as the terminus of the world's first passenger railway, which was opened in 1825, and known as the Stockton & Darlington Railway.

The town is known worldwide for its engineering works both recent such as Cummins, Whessoe Engineering and older more established works such as the Cleveland Bridge & Engineering Company which built bridges all over the world such as over the Amazon and Nile as well as parts of the new Wembley Stadium. Nearer home Middlesbrough's famous Transporter Bridge as well as the Humber Bridge were both built by the company, which still has its HQ in the town.

However, this book is not a history or even a factual narrative of Darlington. It is a picture postcard view of a town much loved town both by its inhabitants and many a visitor; a town with a rich history and some wonderful architecture

spanning many eras. This introduction to Darlington is merely a scene setter with snippets of information to give the reader a little insight into its past - particularly its recent past as the old picture postcards contained within are mostly from the early 20th century, with the majority being from the golden age of the postcard during the Edwardian era, with some into the war years and beyond.

The photographs and paintings on these cards can transport us back to streets devoid of modern transport, and people of all classes taking trams or horse drawn cabs to their places of work or maybe to shop, or simply homeward bound. Many people can be seen walking and strolling along cleaner and less congested streets. This is a Darlington of not too long ago, the Darlington of our great grandparents, the Darlington that was, but that is still recognisable in many of the scenes today as many areas of the town have escaped the worst aspects modern comprehensive redevelopment.

I hope therefore that you will enjoy this nostalgic look back at Darlington as viewed through the images depicted in the old picture postcards from our recent past.

Araf Chohan

CENTRAL DARLINGTON

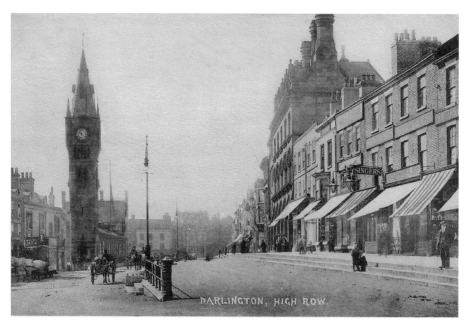

The selective use of colour adds vibrancy to this black and white photograph. Many lamented the loss of some of the Victorian buildings along High Row, seen here at the right of the picture.

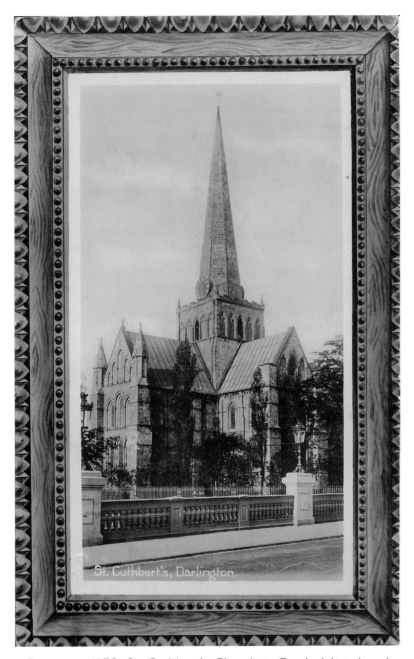

St. Cuthbert's, Darlington.

Dating to 1153, St. Cuthbert's Church is Grade I listed and one of the oldest structure standing in the town. It sits off the marketplace and is still an important an active place of worship in the town. Many old postcards and views of Darlington feature this church, which is one of the most important in the region.

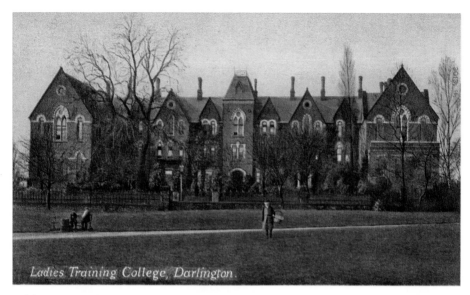

Ladies Training College, Darlington.

More recently known as Darlington Arts Centre, this building was built in 1875 to house 75 "mistresses" for learning.

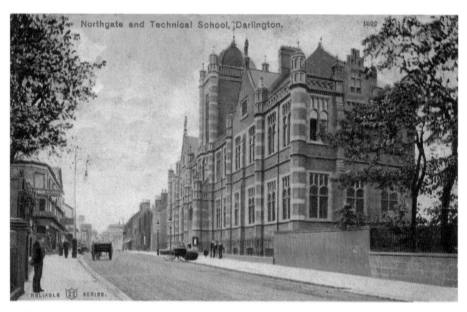

Northgate and Technical School, Darlington. 1902

Darlington Technical College was designed by George Gordon Hoskins and opened in 1897 on Northgate. It was an important place for developing the skills of manufacturing and commerce in the town, but demand later meant other buildings had to be added around the town. This building still stands today and is used as a home for various services by the local council.

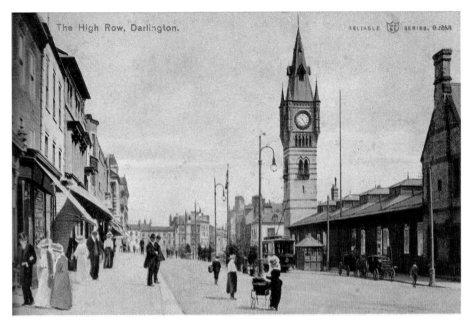

Elegant gentlemen and ladies browse the shops along The High Row under the towering presence of the clock tower.

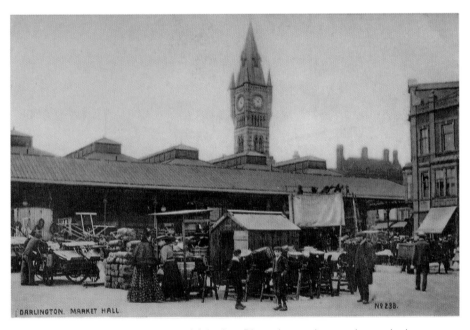

Darlington's Market Hall and Market Place have changed very little since this postcard was produced in the early 1900s.

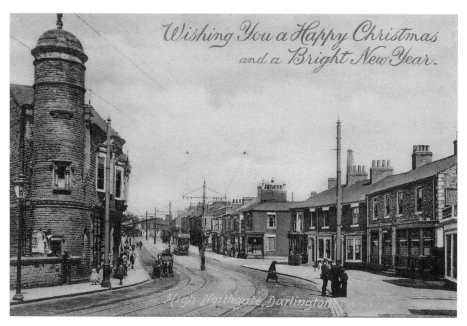

A postcard produced for the Christmas and New Year period in 1907, showing the tram lines and buildings along High Northgate. The impressive building on the left has now disappeared, but those on the right are still standing.

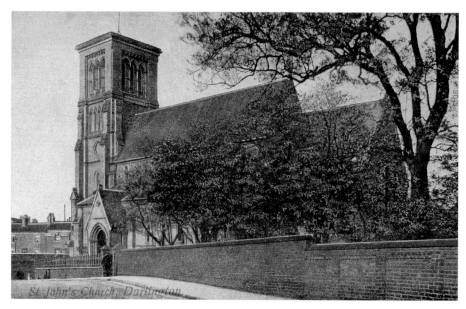

Still a landmark today, the tower of St. John's Church sits close to Bank Top Station and on the busy corner of Yarm Road and Neasham Road.

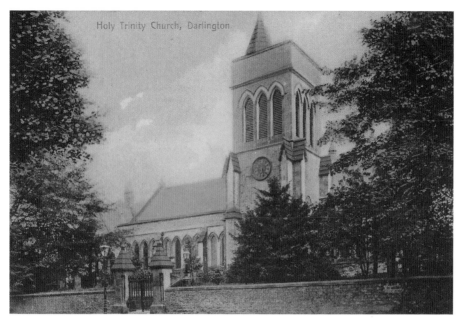

Raised above Woodlands Road, Holy Trinity Church has an unusual tower which can be seen above the trees and rooftops of surrounding buildings. It is a Grade II* listed building built in the 1830s, and an active church today.

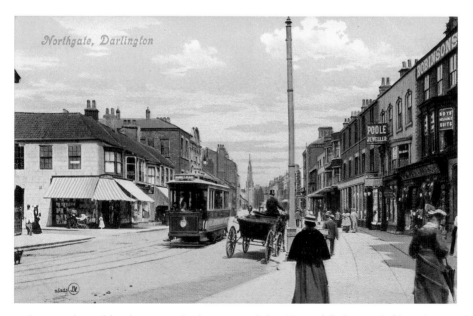

A view along Northgate with the spire of the United Reformed Church in the distance. Note the busy scene of lost shops, a tram and a horse and cart.

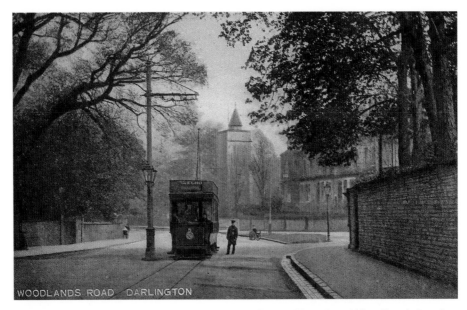

An almost rural scene looking towards Holy Trinity Church on Woodlands Road. This view still exists, however the tram has been replaced by busy road traffic.

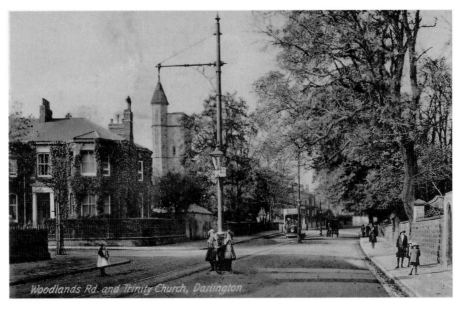

Looking along Woodlands Road in a different direction. The unusual design of Holy Trinity Church's tower can be seen above the rooftops. In the foreground and along the pavements the presence of so many children suggests this photograph was taken shortly before or after the school day.

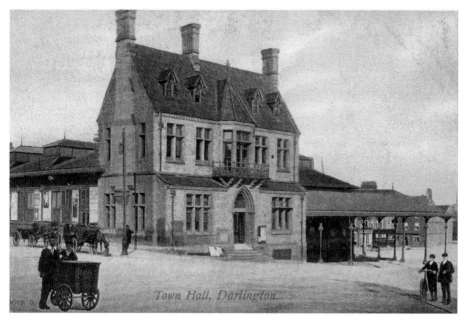

Only the modes of transport and fashions have changed from this Edwardian scene of Darlington's old Town Hall, in a scene that otherwise looks very much the same today.

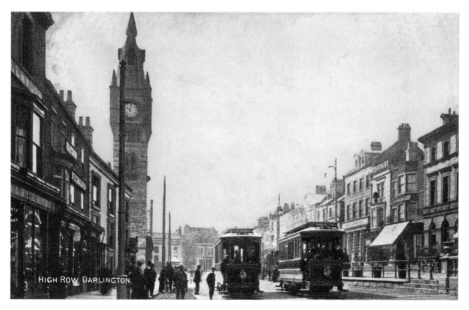

The hub of central Darlington is High Row. This view will be familiar to many today, however trams have long since been replaced by a busy bus network.

DARLINGTON LIGHT RAILWAYS, OPENED 1st JUNE, 1904.

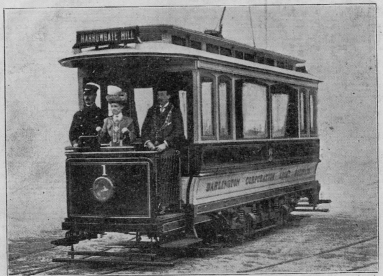

Car Driven by the Mayoress (Mrs. Henderson).

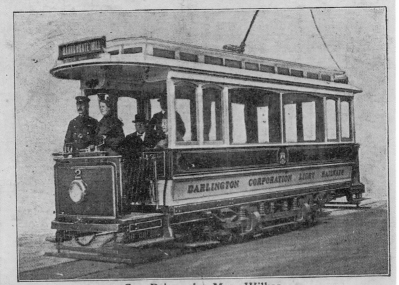

Car Driven by Mrs. Wilkes.

Northern Echo Snapshots.

This card was produced by The Northern Echo to commemorate the opening of the Darlington Light Railways tram system on 1st June, 1904. Two prominent ladies of the town were invited to drive trams on the opening day. (Picture courtesy of The Northern Echo)

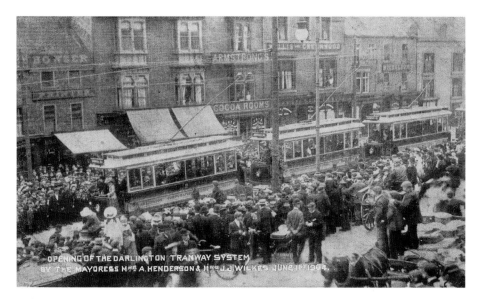

Another photograph of the opening day of Darlington's light railway network in 1904. The significance and celebration of the event is evident from the crowds as a fleet of trams process through the town.

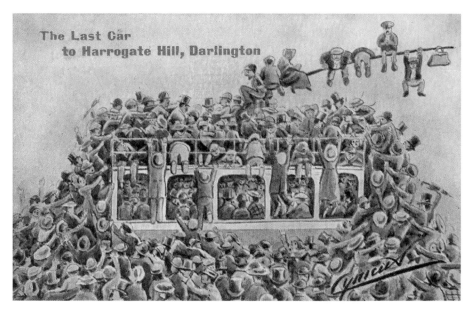

This cartoon card is an interesting snapshot of life in Darlington. It depicts workers from the town catching the 'last car to Harrogate [sic] Hill', a large suburb at the northern edge of the town where many who worked in the railway shops and other industries would have lived.

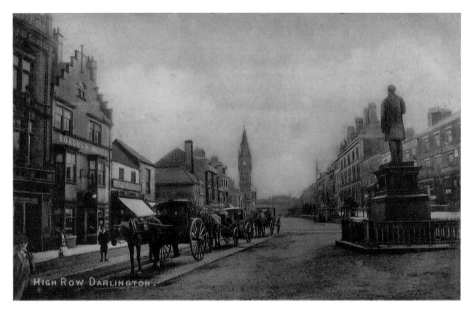

Horse and carts line up outside the Borough Hotel next to the memorial to Joseph Pease on the High Row.

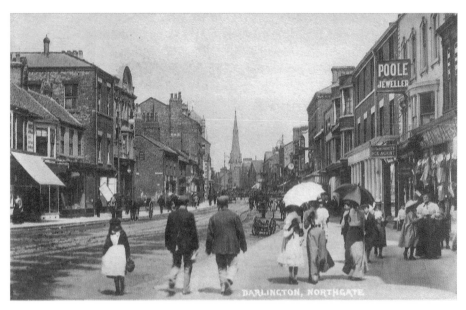

Northgate looking north with many businesses that have been long lost, such as the Bay Horse Hotel on the left. The spire of the United Reformed Church is still a familiar landmark.

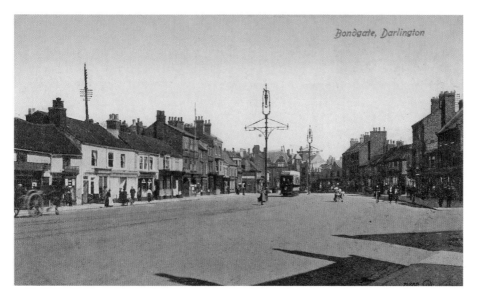

This photograph was taken from what is now a busy roundabout connecting the Ring Road with Bondgate and Woodlands Road. Many of the buildings in this view are still standing, however. The King's Head Hotel can be seen in the distance.

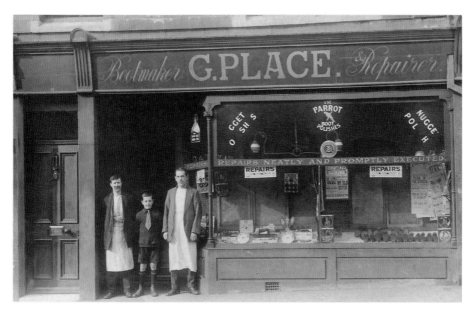

A typical shop front in Darlington, showing G. Place – likely one of the men posing in the doorway – who undertakes bootmaking and repairs which are 'neatly and promptly executed'.

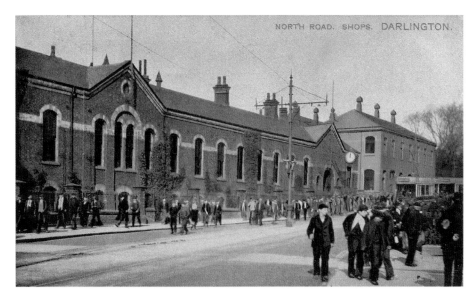

NORTH ROAD. SHOPS. DARLINGTON.

As workers spill out of the North Road Shops at the end of their shift two trams collect a number of them for the journey home. The original clock was restored following the demolition of the Shops and still hangs on the same site, which is now occupied by a supermarket.

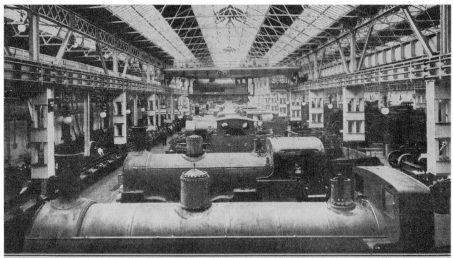

INTERIOR OF NORTH ROAD LOCOMOTIVE WORKS, DARLINGTON—A 70 TON OVERHEAD CRANE CARRYING A LOCOMOTIVE.
From an original photograph kindly presented by Vincent L. Raven, Esq., Chief Mechanical Engineer.

As the caption explains, this postcard of the interior of the North Road Locomotive Works demonstrates the scale of the operation at its peak, when new locomotives were rolled off the production line and impressive cranes hoisted them to new positions in the factory.

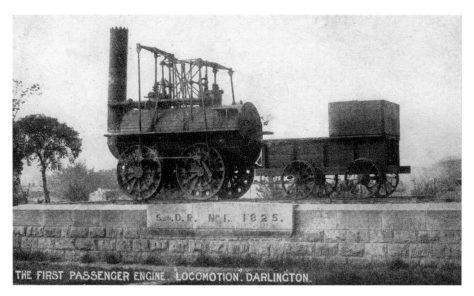

Darlington is famous for its connection with the world's first railway, the Stockton & Darlington. For a time, George Stephenson's "Locomotion", which ran on the line, was displayed outside North Road Station as a memorial.

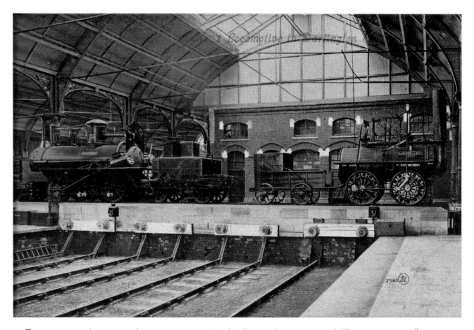

For a time historic locomotives, including the original "Locomotion" were on display inside Bank Top Station, celebrating the town's railway heritage for all visitors to see.

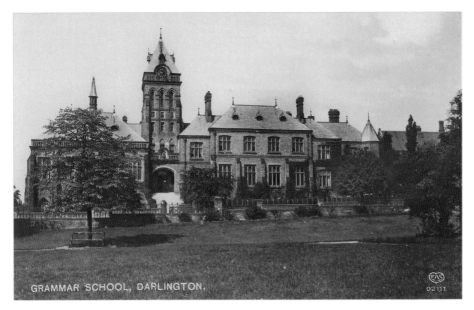

GRAMMAR SCHOOL, DARLINGTON.

A George Gordon Hoskins structure in central Darlington was the Queen Elizabeth Grammar School, seen here from Stanhope Park. Situated on Vane Terrace, it is today the Queen Elizabeth Sixth Form College.

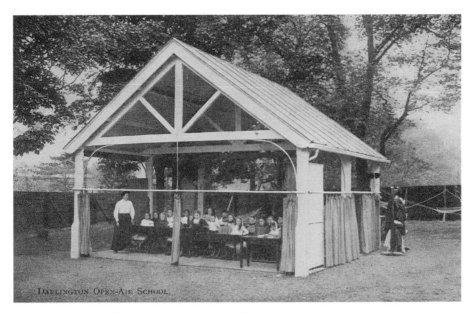

DARLINGTON OPEN-AIR SCHOOL.

The Open-Air School on Gladstone Street in Darlington was seen as a revolutionary idea when it opened in 1910 to offer the benefits of fresh air with learning. Inclement weather sadly forced its closure in the same year.

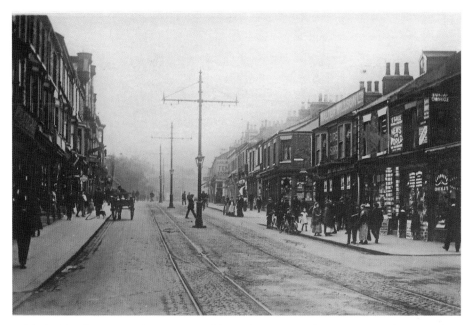

High Northgate is a busy scene. Shops here are advertising products such as Cadburys, Rowntree, the Sunday Chronicle and the News of the World.

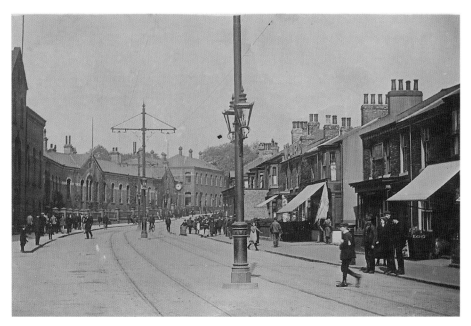

A 1914 view looking north towards the railway works on North Road with its famous clock.

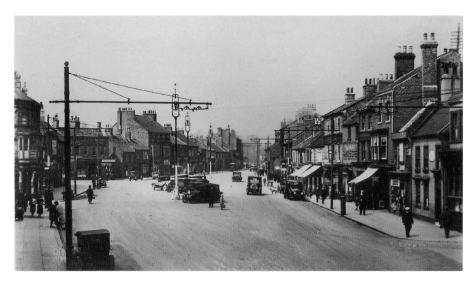

The two postcards on this page could be used as a game of spot the difference. Both show Bondgate around 20 years apart. This first image was posted in 1930, suggesting it was taken in the late 1920s, which is supported by the vehicles in view.

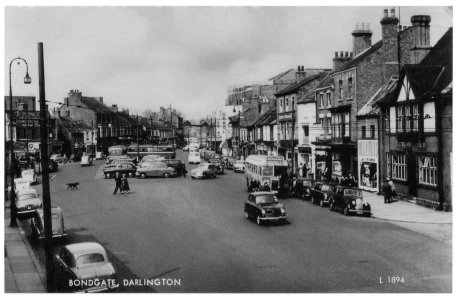

In this second view from roughly the same position, the buildings are largely the same, but the businesses have changed and motor vehicles have certainly advanced. The Odeon Cinema is clearly visible in the distance, which opened in 1945 in what was formerly the Majestic picture house.

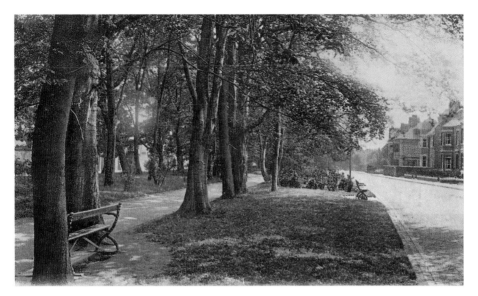

This leafy footpath alongside Grange Avenue on the southern entrance to central Darlington can still be enjoyed, albeit with much more traffic passing along the busy main road.

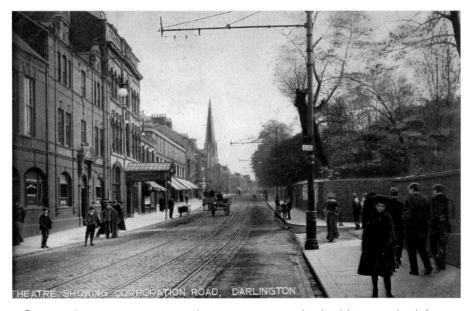

Present-day cinemagoers might not recognise the building on the left as Darlington's Odeon cinema on Northgate. Opened as the Theatre Royal in 1885, but was largely rebuilt when turned into the Regal Cinema in 1938. It would later be known as the ABC, Cannon and MGM.

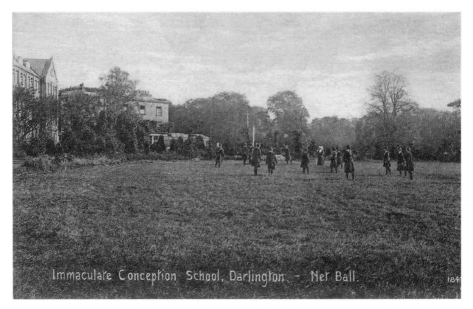

Immaculate Conception School, Darlington – Net Ball.

The Immaculate Conception Grammar School was a girls' only Catholic place of education which was merged with St. Mary's School to form Carmel School in 1974. This scene shows the girls playing netball and a nun acting as a referee.

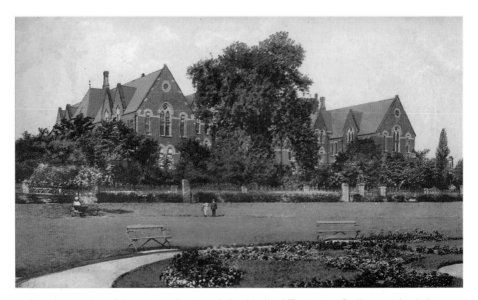

Another colourful postcard view of the Ladies' Training College, which later became the Art Centre. Stanhope Park in the foreground is a manicured space amongst the grand Victorian houses of the surrounding streets.

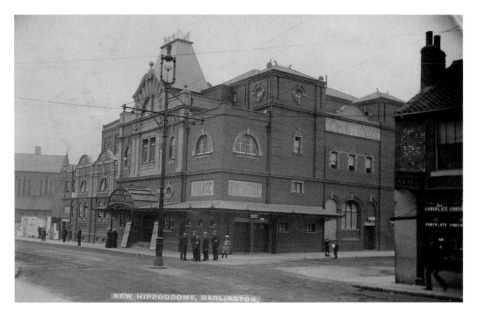

Darlington's Civic Theatre was first opened as the New Hippodrome & Palace of Varieties in September 1907. Its first manager was Signor Rino Pepi, an Italian performer who made the move into theatre management. Its name was changed in 1966 when it came under the ownership of the Borough Council.

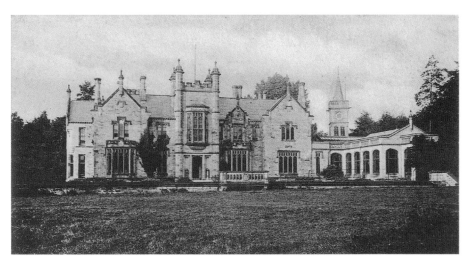

One of a number of grand houses located in Darlington's suburbs was Pierremont. It was owned by Henry Pease, one of the directors of the Stockton & Darlington Railway. Today the house has been separated into five separate residences.

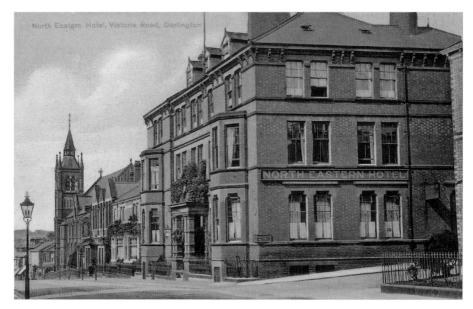

A scene which greeted many visitors to Darlington as they exited Bank Top Station and looked down Victoria Road. Many would spent a night at the North Eastern Hotel.

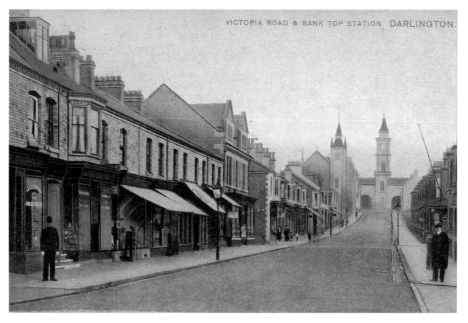

Looking in the opposite direction, this painting depicts a smart scene of shopfronts and the towers of the station and Methodist church.

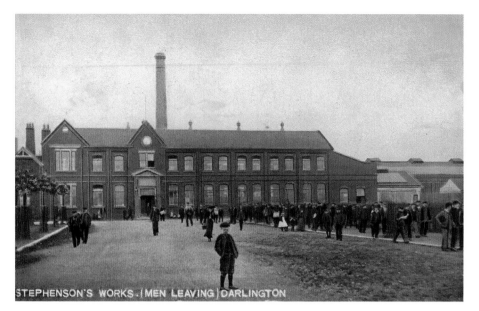

Robert Stephenson and Company's works moved to Darlington from Newcastle in 1902, producing many steam engines for railways. Many of the town's working men were employed there, and many moved to the town to find work on the railways.

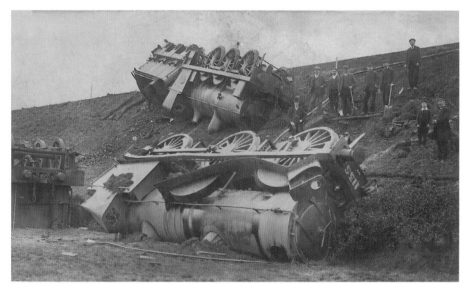

An unusual subject for a postcard, but an interesting record nevertheless. A double-headed freight train was derailed between Winston and Darlington, before falling down the embankment, on 24th October 1905.

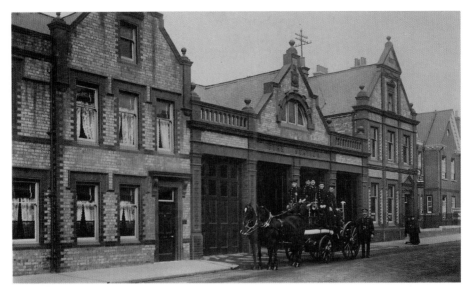

Firemen pose outside the old fire station on Borough Road, with their horse and cart transport for attending emergencies. This card was posted in 1909.

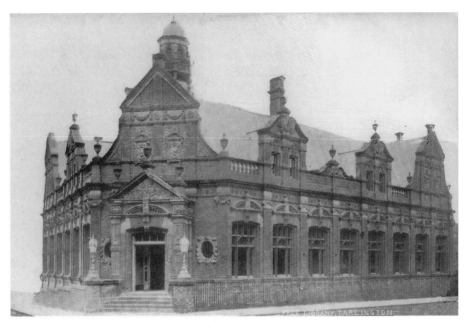

Crown Street's imposing Public Library was gifted to the town by Edward Pease, who left £10,000 in his will for its construction. It opened five years later, in October 1885.

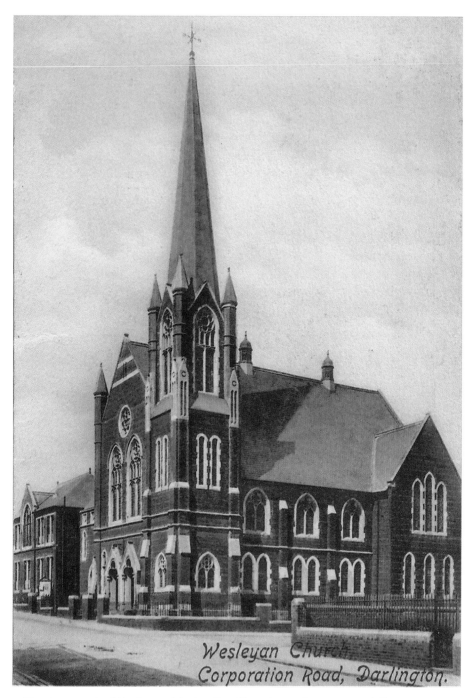

Wesleyan Church Corporation Road, Darlington.

The impressive Wesleyan Methodist Church on the corner of Corporation Road. It was demolished in the 1960s.

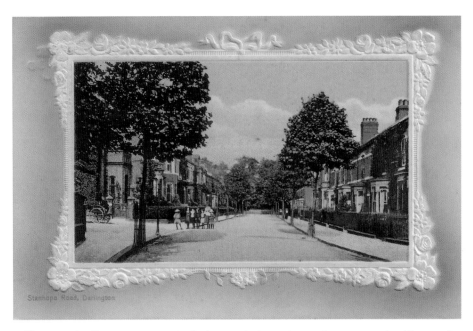

This card offers an attractively framed view along the smart dwellings of Stanhope Road to the west of the town centre.

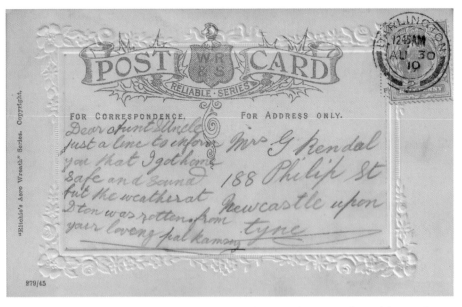

The rear of the card tells us that the sender was letting a friend know that they had returned safely to Darlington, despite the "rotten" weather. The postmark is 30th August 1910

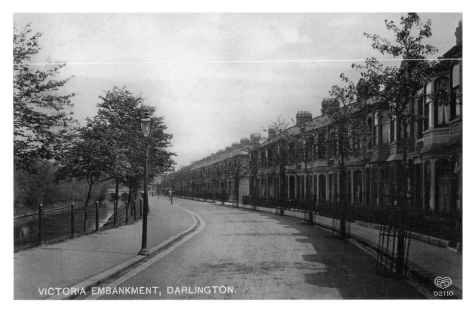

The elegant curving row of Victorian terraces along Victoria Embankment. The bridge visible in the distance was replaced by a modern concrete structure when the inner ring road was built from 1967, cutting off this street from the nearby town centre.

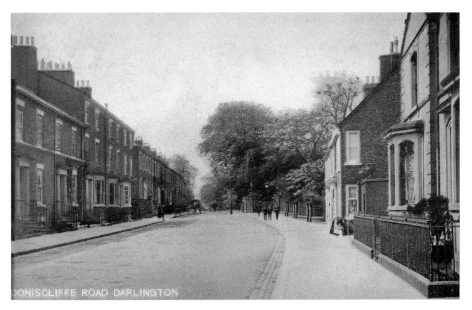

A colourful view along Coniscliffe Road from an original black and white photograph taken around 1907.

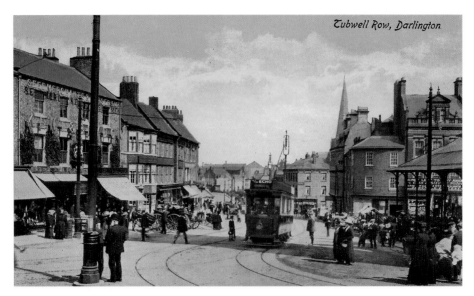

Tubwell Row, Darlington

A lively 1917 scene looking down Tubwell Row with a tram working its way uphill and the busy market to the right. Behind the buildings is the spire of St. Cuthbert's Church, and the rear of the Hippodrome Theatre can be seen on the horizon.

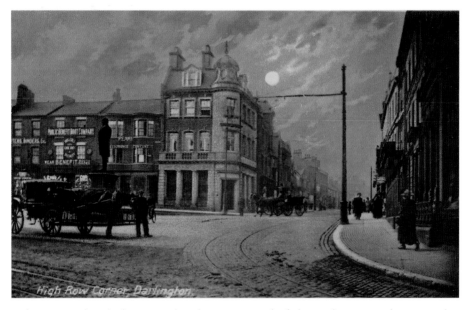

An unusual twilight scene has been created of this colour tinted postcard showing High Row Corner, with a full moon and shadowy figures on the street. It dates from 1914.

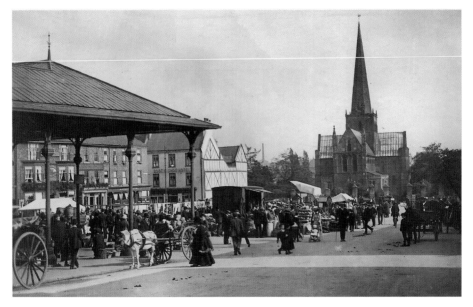

A 1915 view of St. Cuthbert's Church and the market busy with traders and shoppers. The many public houses lining the Market Place always did a good trade from market days.

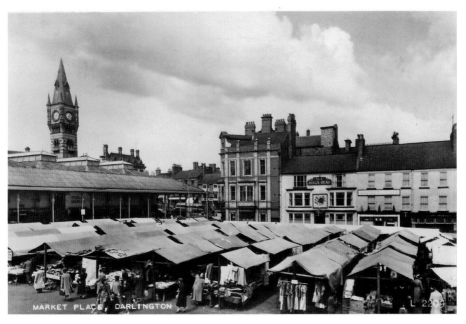

Darlington's Market Place in 1956. The covered market was designed by Alfred Waterhouse, who also designed London's Natural History Museum

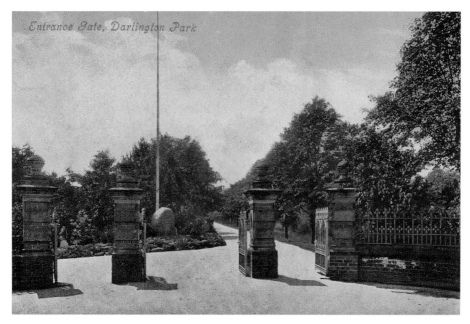

The entrance gate to South Park has changed very little and still see many thousands of visitors passing through every year.

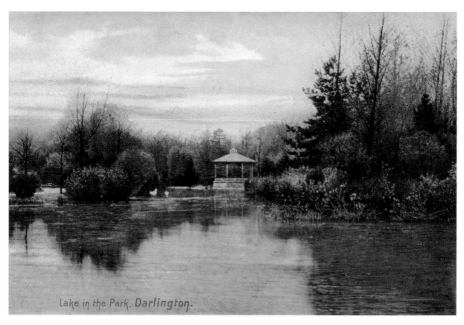

A serene scene showing a painting – possibly from an original photograph – of the 'Lake in the Park' at South Park.

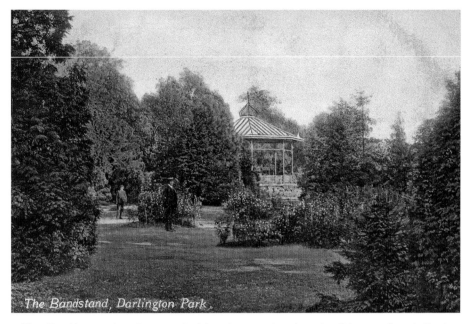

The Backhouse family provided funding to develop the 91-acre South Park in 1853 as a tranquil place to escape the busy town and industry.

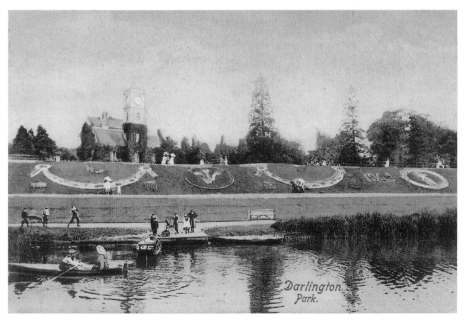

People enjoy rowing on the River Skerne as it passes through South Park. This postcard is from 1904.

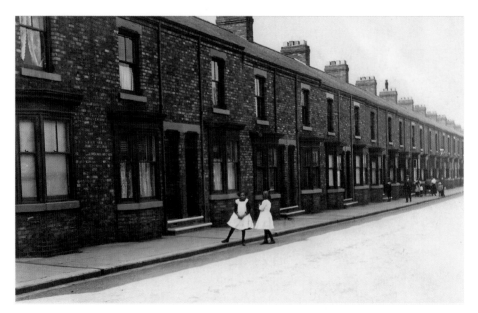

Rows of terraced houses were built, such as those along Bartlett Street, to cater for the influx of workers moving to the town with the railways and other industries during the 1800s.

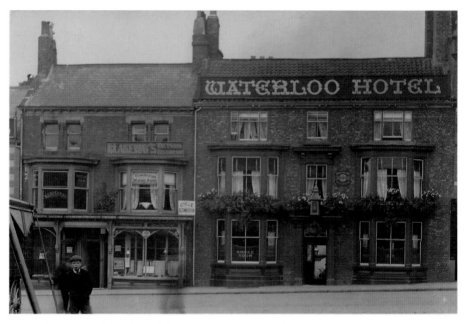

The Waterloo Hotel and Blakeway's Victoria Restaurant and Commercial Dining Room on Horse Market in 1906.

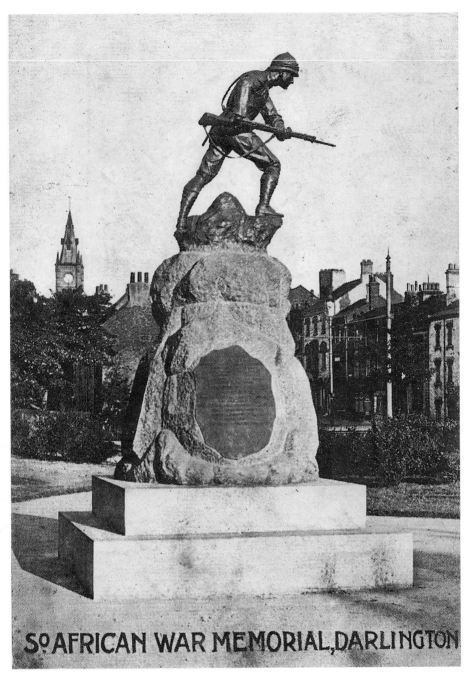

So AFRICAN WAR MEMORIAL, DARLINGTON

Standing in the grounds of St. Cuthbert's Church, this memorial is to the men of Darlington who died in the Boer War between South Africa and Britain from 1899 to 1902.

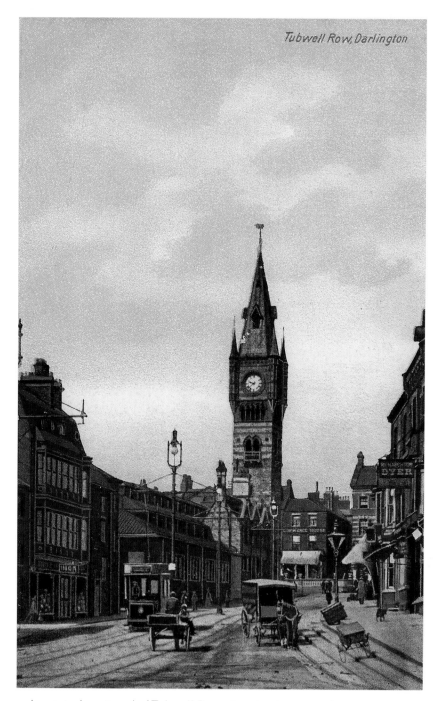

A painted postcard of Tubwell Row, showing horse and carts, a tram, the Victorian market and clock tower.

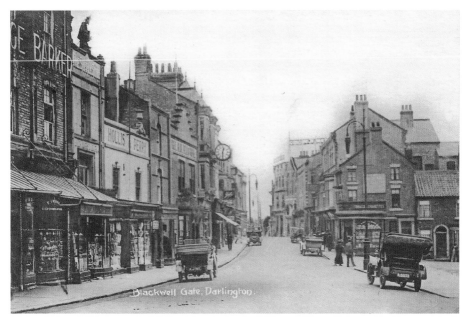

Blackwell Gate leading towards High Row in 1920.

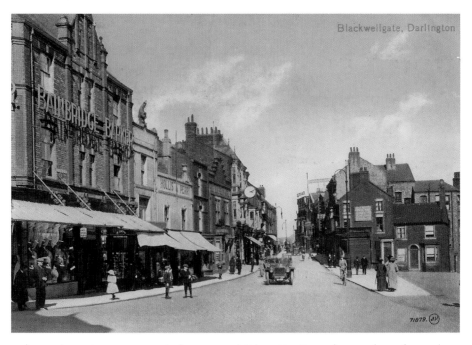

An early motorcar seems to have caught the attention of a number of people as it passes through Blackwellgate towards the camera in 1916.

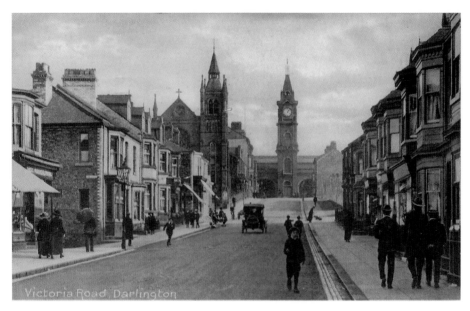

Darlington is a town built on the railways. This impressive vista culminates in the tower and arches of the grand Bank Top Station, built to replace the original structure on the site in the 1880s as the importance of rail routes into the town grew.

Polam Hall is a name known to many who have been educated in Darlington. However, the boarding and Free School of today started life as a private residence built in 1794. It became a Quaker ladies' finishing school in the 1850s. Boys were finally allowed to attend in 2004.

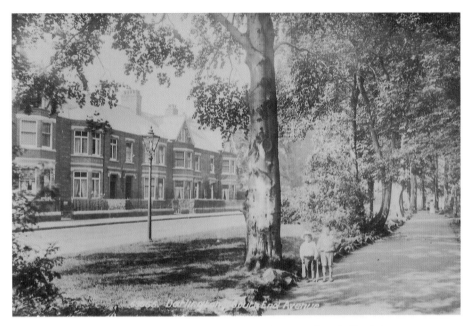

Two small children pose with their cricket bat on South End Avenue on a bright sunny day.

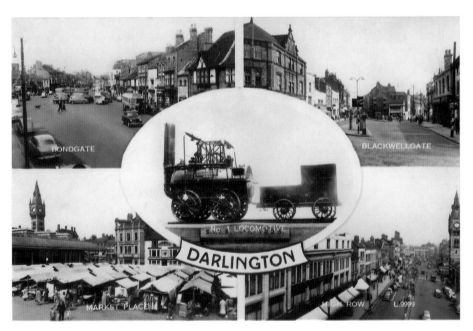

Five scenes of central Darlington are represented on this tourist postcard, with the town's most famous export, the railway, in the centre.

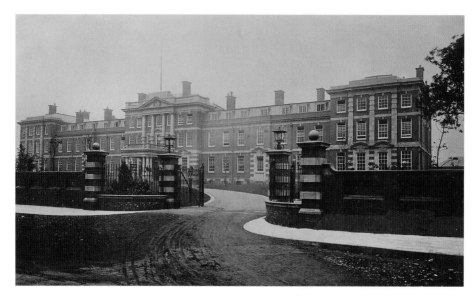

It was only fitting that a town with such an important railway heritage as Darlington should have the presence of one of the important railway companies of the time. The North Eastern Railway (NER) offices were opened on Brinkburn Road in 1911, and this card was produced to commemorate the impressive building.

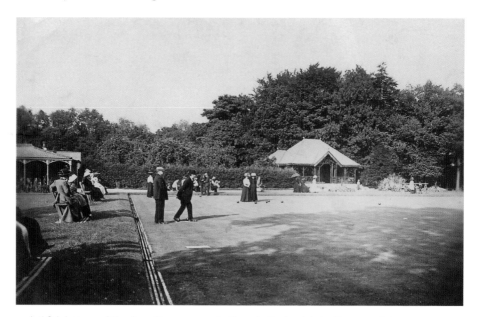

A 1914 view of the bowling green in South Park with ladies watching a game being played out.

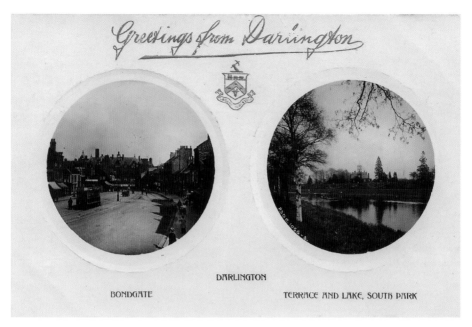

An unusual postcard from 1908 showing two scenes from the town – Bondgate looking towards the King's Hotel, and South Park's lake and terrace.

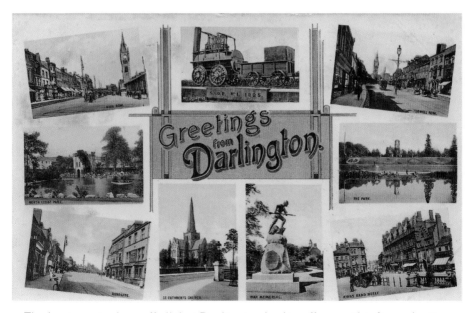

The best way to show off all that Darlington had to offer was this fine selection of colour tinted scenes from around the town, including its commercial heart, parks, churches, war memorial and the most famous railway locomotive.

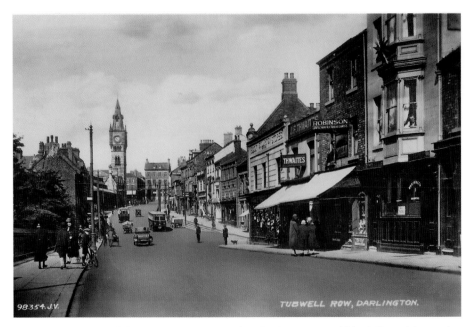

Tubwell Row in 1937 looking towards the clock tower and High Row. Many of the buildings on the right were replaced by the Cornmill Shopping Centre in 1992.

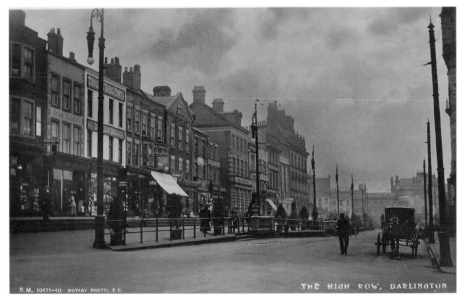

An atmospheric view looking along the imposing façades of the High Row, housing banks, traders and shops.

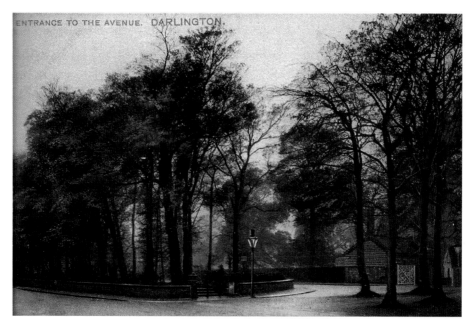

The entrance to the Avenue leading south towards Blackwell. Where the photographer stands is now a busy roundabout where the inner ring road joins Grange Road and Coniscliffe Road.

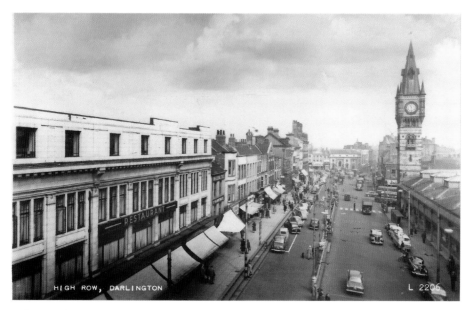

Binns department store is a prominent addition to the High Row, as well as much more vehicle traffic on the road, in this 1957 photograph.

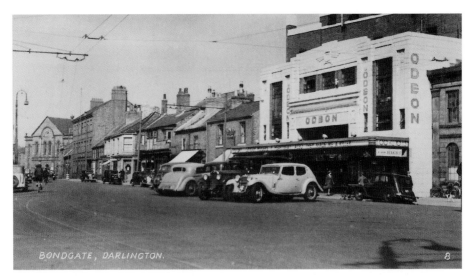

The Odeon Cinema on Bondgate was built in the iconic art-deco style of the 1930s. Originally known as the Majestic, the building has recently been brought back into use as an entertainment venue of the same name after years operating as a snooker hall.

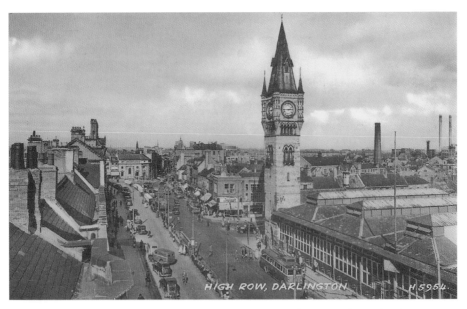

Looking down on the High Row, clock tower and covered market from an elevated vantage point. Motor vehicles had very much taken over here, and a trolleybus can be seen outside the market. Note the chimneys of Darlington's lost power station in the distance on the right side of the picture.

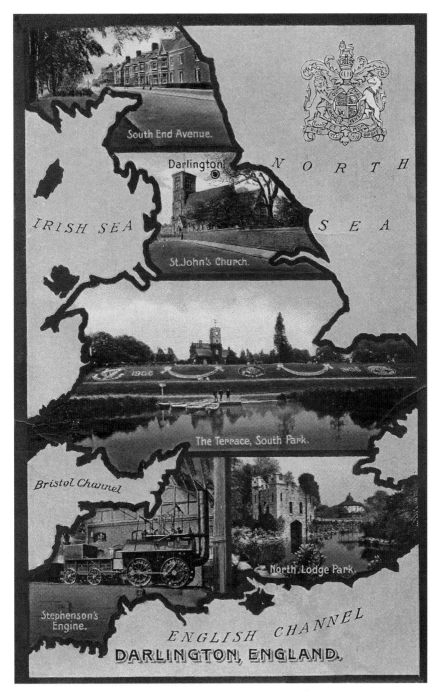

South End Avenue.

Darlington.

NORTH

IRISH SEA

SEA

St. John's Church.

1906

The Terrace, South Park.

Bristol Channel

North Lodge Park.

Stephenson's Engine.

ENGLISH CHANNEL

DARLINGTON, ENGLAND.

Five important scenes from Darlington, plus the location of the town, set within a map of Great Britain.

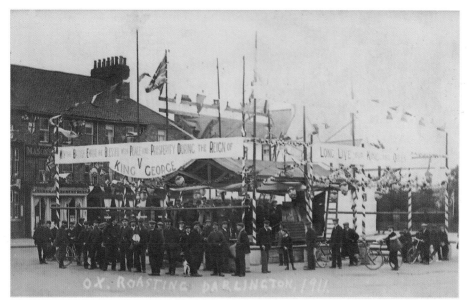

King George V's reign started in 1910. This commemorative ox roasting in Darlington took place in 1911, with banners wishing blessings and prosperity on the British Empire during his reign.

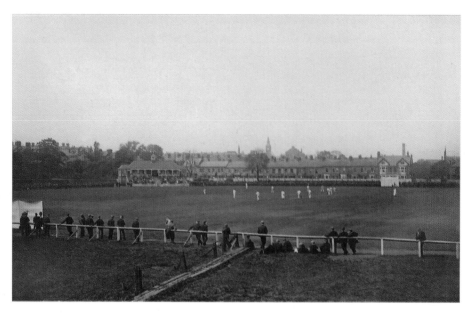

The Darlington Cricket and Athletic Club Grounds at Feethams in 1911. The elegant pavilion had been built as a result of the grounds becoming a distinguished gentlemen's club that was frequented by important Quakers.

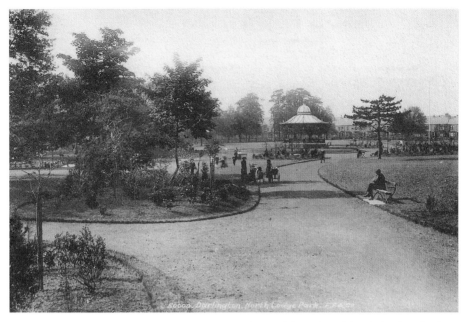

The bandstand and paths leading through the Edwardian North Lodge Park.

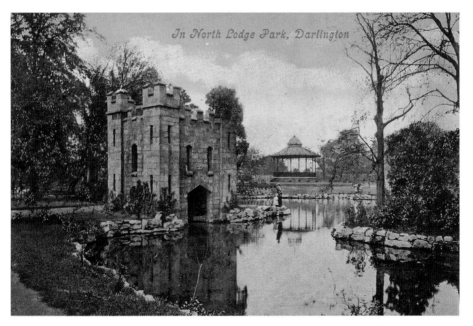

The boathouse in North Lodge Park was built to resemble a Norman keep alongside the lake, which was quite effective. Sadly it no longer exists, but is preserved in this colourful Edwardian postcard.

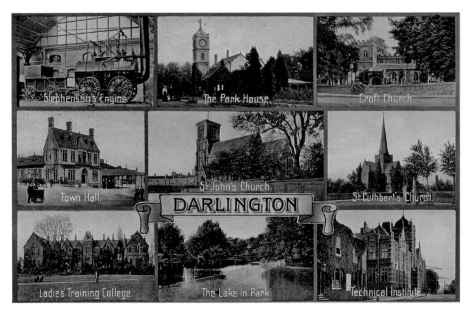

This car reproduces nine separate colour tinted photographs of some of Darlington's most important buildings and sights, including the Technical Institute, St. Cuthbert's Church, the Ladies' Training College, South Park, and George Stephensons' "Locomotion" steam engine.

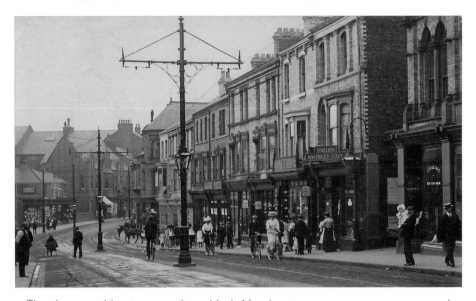

The shops and businesses along High Northgate were once numerous, and an extension of the town along the great North Road before the ring road separated it. All of the buildings behind the cyclists have now been demolished.

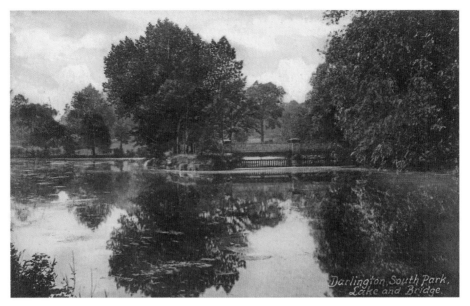

The old bridge across the lake in South Park leading to the wooded island.

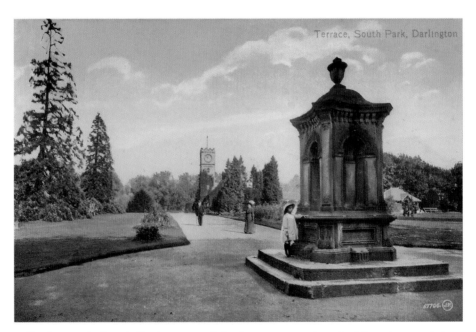

Darlington's South Park is one of the finest examples of a Victorian park in the country. This surprisingly colourful view is from a modified black and white photograph of 1905 showing the terrace leading into the park from the entrance.

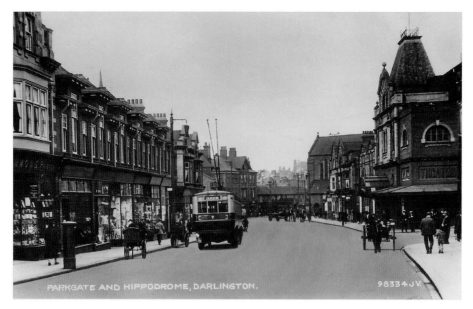

A busy 1930s scene looking along Parkgate toward the centre of Darlington. The Hippodrome (now the Civic Theatre) and many of the buildings are still in use today, however the lower buildings at the end of the street were demolished before the ring road was built.

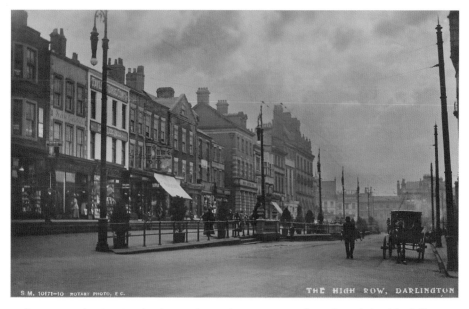

An atmospheric view looking along the imposing façades of the High Row, housing banks, traders and shops.

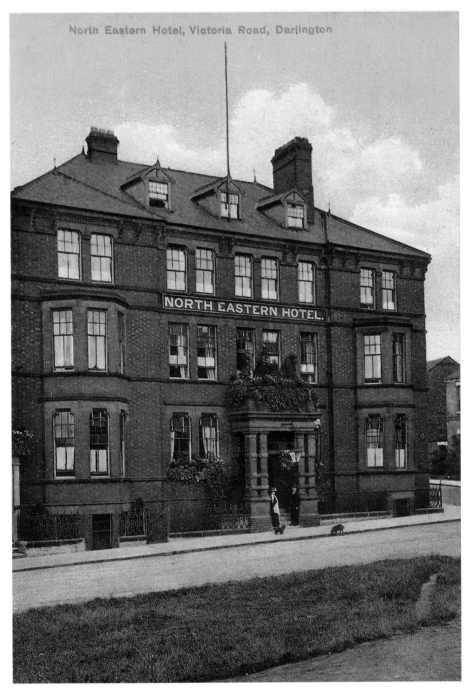

North Eastern Hotel, Victoria Road, Darlington

NORTH EASTERN HOTEL.

Along with an impressive Victorian railway station came the equally grand North Eastern Hotel, built in 1870 and still used as a hotel today.

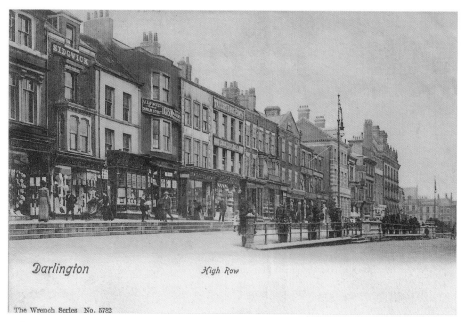

Darlington High Row

The Wrench Series No. 5782

Some of the businesses visible along the High Row here include Taylors' Drug Company, London Leeds, Hull & Company, Dickson, Sidgwick and Mantles.

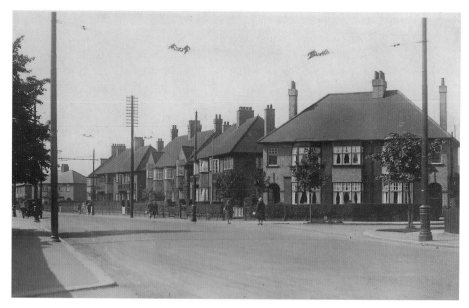

A slightly later scene of Yarm Road. A truck can be seen in the distance, and lines for trolleybuses are in place above the road.

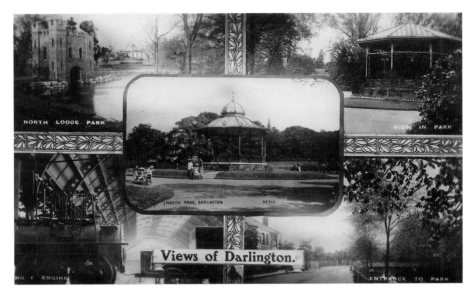

These views of Darlington are largely dominated by scenes from the town's parks, with the addition of the 1825 "Locomotion No. 1" engine on display in Bank Top Station.

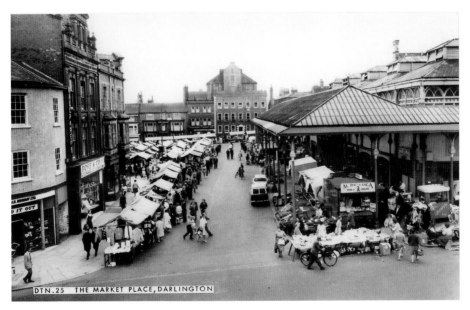

A more recent view of the Market Place in Darlington which is not too dissimilar to the view today, the only difference being in the names of the shops and businesses, and the types of vehicles use by traders. One other notable difference is the absence of the Dolphin Centre, which was opened in 1983.

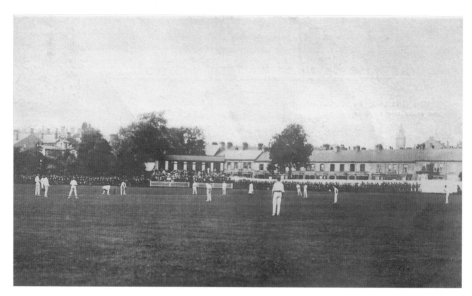

Sydney H. Wood's photographic gallery was on Blackwellgate. It produced this postcard showing Darlington Cricket Club winning the championship at Feethams. The card was posted in 1911, however the team won numerous times in the early 1900s.

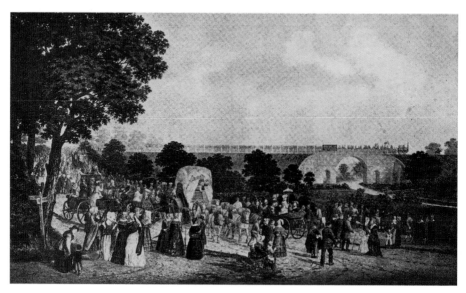

One of the most significant events in Darlington's history is commemorated in this postcard, showing crowds watching the first steam locomotive passing over the Skerne Bridge on 27th September 1825 as it made its way towards Stockton on the world's first public railway.

VILLAGES WITHIN DARLINGTON

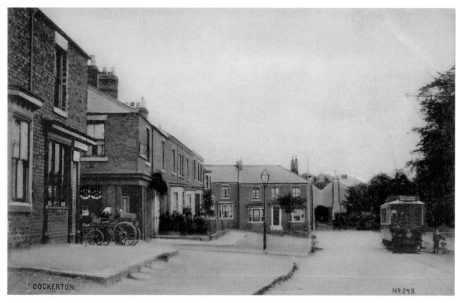

Cockerton is fully incorporated as a suburb of Darlington by the time of this postcard, with a tram awaiting passengers at the end of the line which ran along Woodlands Road.

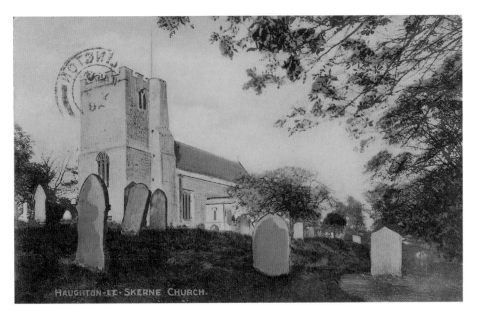

St. Andrew's Church in Haughton-le-Skerne is the oldest in Darlington, known to originate from around 1125. It is thought that it once belonged to a monastic site, with various remains incorporated into the rectory across the road.

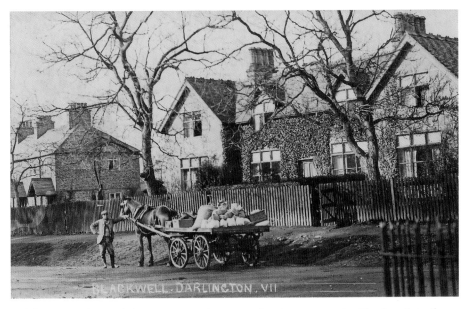

A horse and cart delivering supplies pose for the camera in Blackwell, to the west of central Darlington, in the late 1920s.

The original Cockerton Village set around Cockerton Green and the Cocker Beck. The busy main road would later cut through the position that the photographer is standing.

Cockerton's original village is still identifiable set around its green. The schoolhouse seen on the left in this postcard has now been lost, but the Methodist Church and many of the buildings on the right still stand.

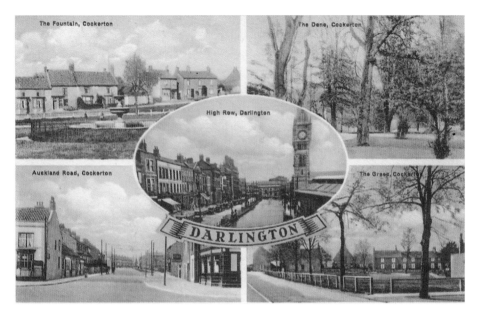

Although a postcard from Darlington, four of the five scenes are from the village of Cockerton to the west, showing the Green and its fountain, the Dene, and Auckland Road.

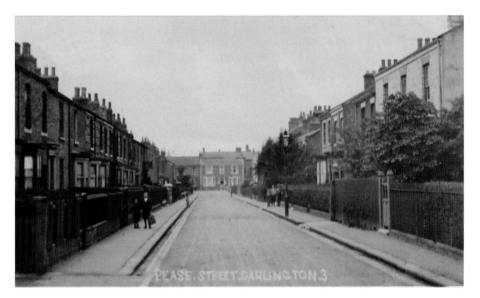

Once a separate village, Eastbourne is now one of the closest suburbs to the centre of Darlington. Some older houses exist along Yarm Road, but in the case of Pease Street, seen here in 1927, the houses came in the Victorian era.

VILLAGES WEST OF DARLINGTON

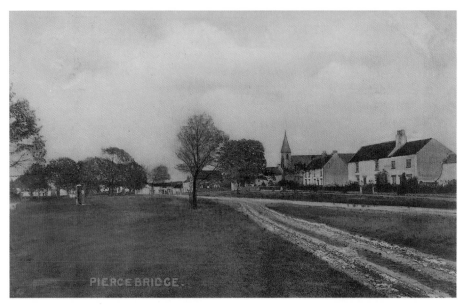

A pleasing country village view showing Piercebridge. From around 70AD this green was the site of the Roman fort built alongside Deer Street and the important crossing point on the River Tees.

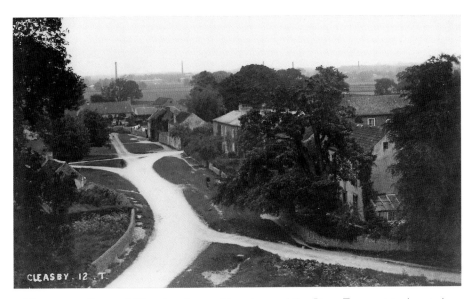

The quiet village of Cleasby situated in a loop of the River Tees existed mainly as an agricultural settlement. Its proximity to Darlington is evident by the factory chimneys seen in the distance.

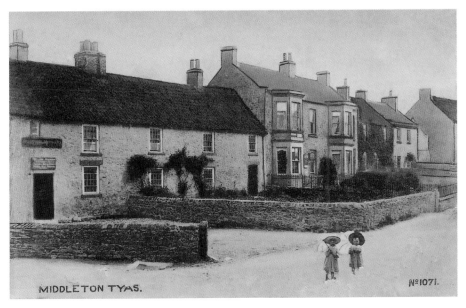

Middleton Tyas has origins in the Anglo-Saxon period. Today it is hidden alongside the busy motorway interchange at Scotch Corner, a few miles south of Darlington. This card from 1908 shows two public houses. The Shoulder of Mutton, on the left, is still in business today.

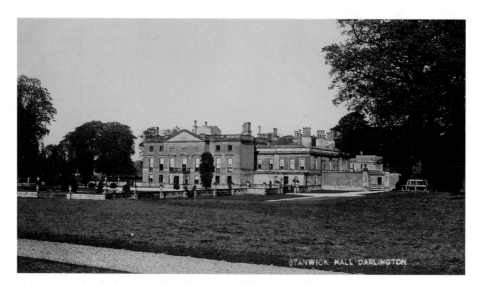

Stanwick Hall close to the village of Aldbrough St. John was owned by the seat of Duke of Northumberland and used as a country retreat. Following use as a hospital in the First World War, a buyer couldn't be found and it was demolished in 1923. Many of the outbuildings still exist, however, as private dwellings and businesses.

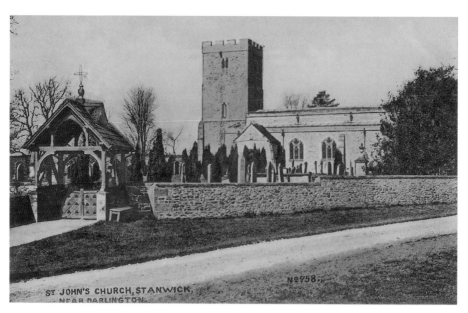

St. John's Church at Stanwick lies quite isolated. It once served the nearby Stanwick Hall and Carlton Hall, as well as the village which has now all but disappeared.

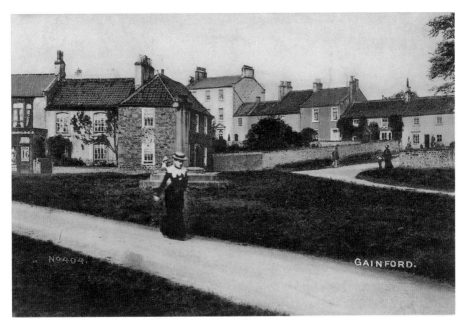

A colour tinted scene of village life in Gainford from a card posted in 1911.

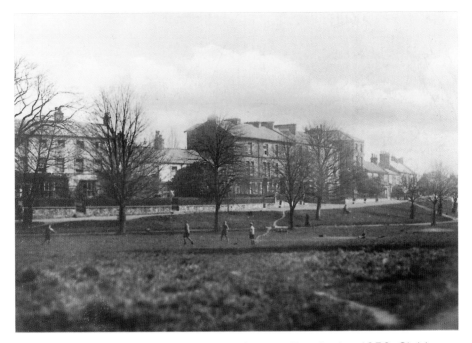

A relatively recent photographic card showing Gainford in 1950. Children play on the green in front of the rows of elegant houses.

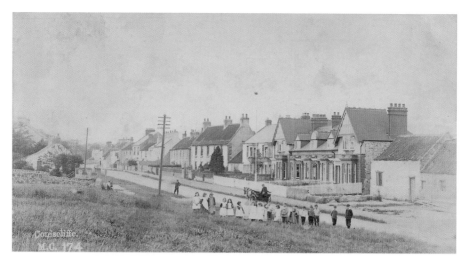

High Coniscliffe, a few miles west of Darlington, has a long history dating to Anglo-Saxon times. This scene from 1904 shows the linear pattern of its houses along the main road, with a group of schoolchildren assembled on the grassy bank opposite.

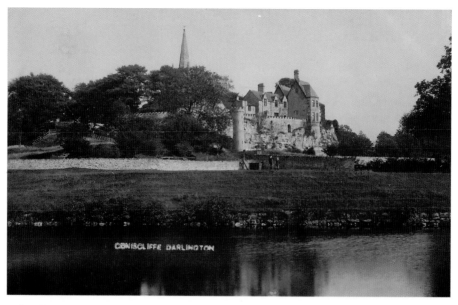

St. Edwin's Church in High Coniscliffe dates from 1170 and has many carved Norman features and an embattled tower. Along with its vicarage, the church is built close to a cliff leading down to the River Tees. A turreted wall was built surrounding the site atop the cliff edge, giving the impression of a fortified castle when viewed from below, as in this postcard.

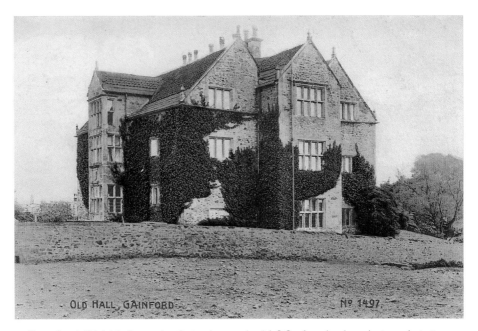

Gainford Old Hall was built in the early 1600s for the local vicar. It is in a Jacobean style and is Grade I listed today, with many interesting features.

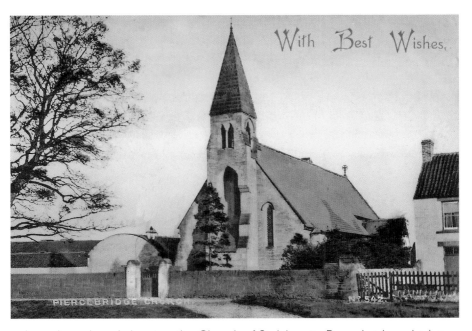

A card produced showing the Church of St. Mary in Piercebridge which is set on the village green, with the remains of the Roman fort behind.

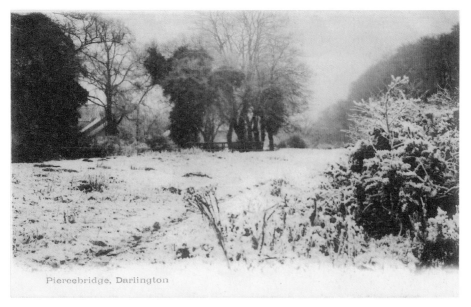

Piercebridge, Darlington

Snow is on the ground in this winter scene of Piercebridge, no doubt showing the area of the former Roman bridge.

ALDBROUGH DARLINGTON

A cricket match makes good use of the open space in Aldbrough St. John. The village green here is thought to be one of the largest in the country and the village was once home to a castle.

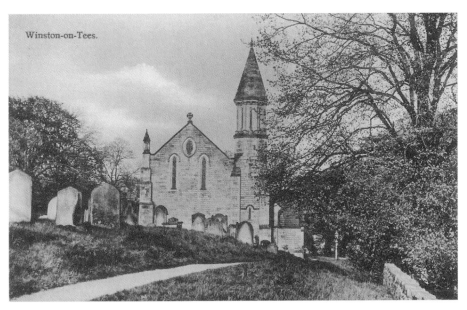

Winston-on-Tees.

St. Andrew's Church stands on the eastern edge of Winston on a spot overlooking the River Tees. It dates from the 13th Century, but was restored and altered in 1848. Today the building is Grade I listed.

CROFT, HURWORTH AND NEASHAM

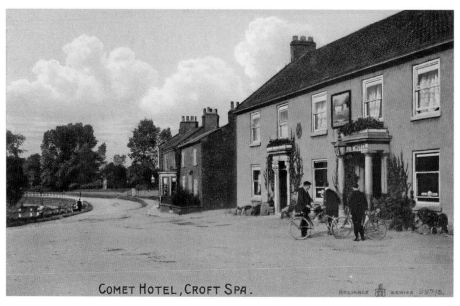

COMET HOTEL, CROFT SPA.

The Comet Hotel in Croft is still a popular watering hole at the junction of the roads to Darlington, Hurworth and Northallerton on the Durham side of the river.

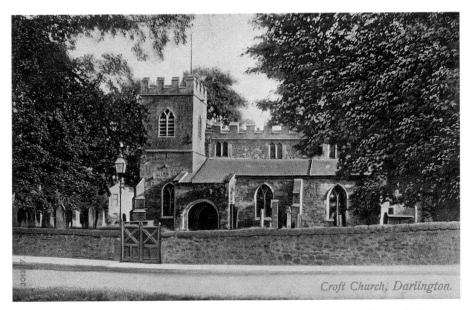

Croft's St. Peter's Church was home to a young Lewis Carroll, who's father was the Rector between 1843 and 1868. He lived in the Rectory here until 1850, and it is said that a carving inside the church inspired his Cheshire Cat character in Alice in Wonderland.

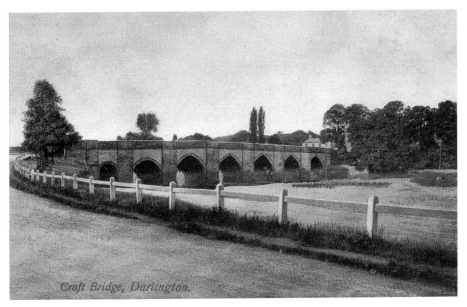

A 1908 painting of Croft Bridge crossing the River Tees, with its seven arches carrying the main road to Northallerton.

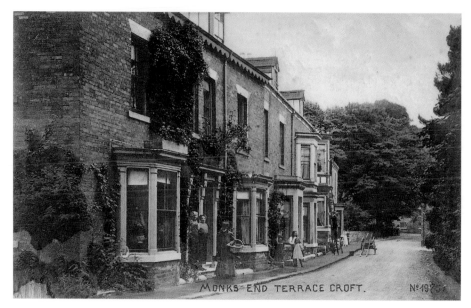

The presence of children, families and workmen bring life to this scene of Monks End Terrace in Croft, leading down to St. Peter's Church, around 1907.

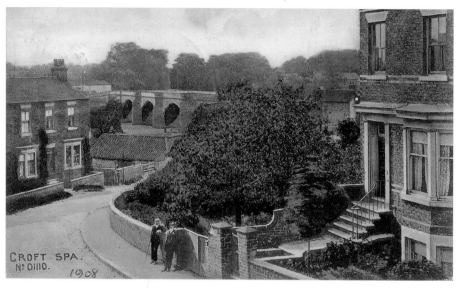

A fine view of Croft looking from Hurworth Road as it rises away from the village. Croft Bridge can be seen in the distance and the trees where the church can be found. Croft Spa Station would have been located behind the photographer in this 1908 scene. It was closed in 1969.

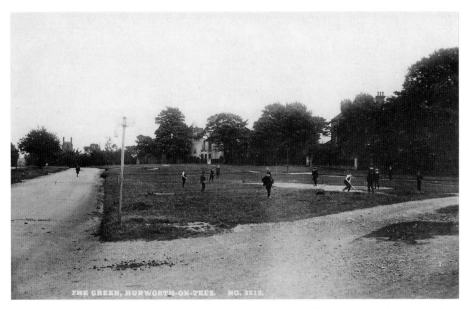

A group of boys play cricket on Hurworth Green. The patch of bare earth suggests this is a regular activity at the time, possibly as part of the local school's physical education classes.

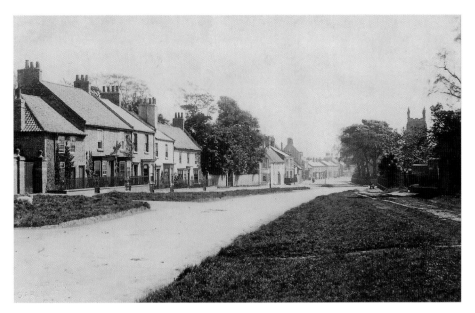

The centre of Hurworth as seen in 1906. The Bay Horse public house is in the distance on the left, whilst All Saints' Parish Church's tower appears behind the trees on the right.

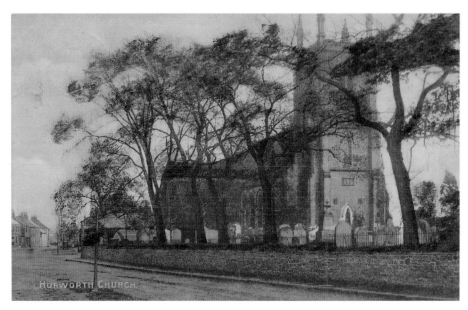

Early postcard producers would often experiment with adding colour to their black and white photographs, with mixed results. This card showing the church of All Saints' with some interesting shades of red.

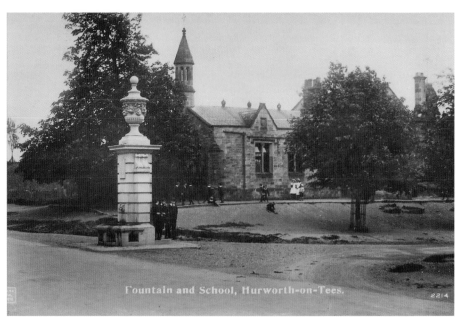

Children play and enjoy recreation time outside the school and nearby fountain in the centre of Hurworth.

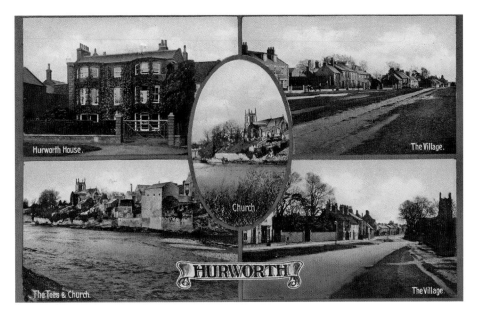

Five scenes of Hurworth village, including an unusual aspect from the opposite bank of the River Tees which most visitors wouldn't see. Hurworth House, in the first scene, was later converted into and independent school.

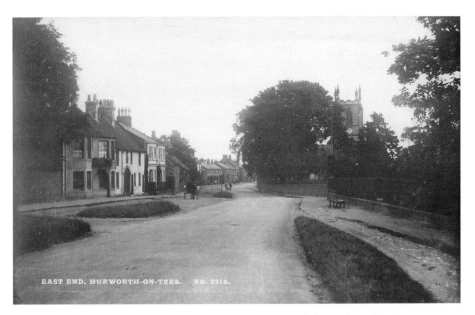

Hurthworth's east end. The Bay Horse is on the left, and in the distance a horse and cart and some locals go about their business in an otherwise quiet scene.

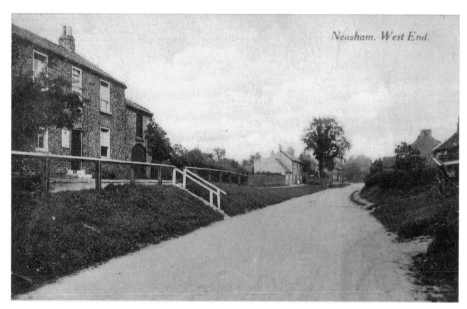

The west end of Neasham, which lies to the east of Hurworth along the banks of the River Tees.

VILLAGES EAST OF DARLINGTON

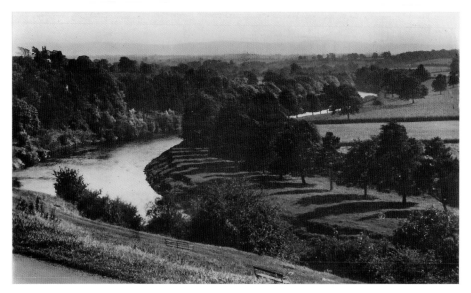

It is no surprise that seats have been installed along The Front in Middleton One Row when the views of the river and distant hills are this pleasant.

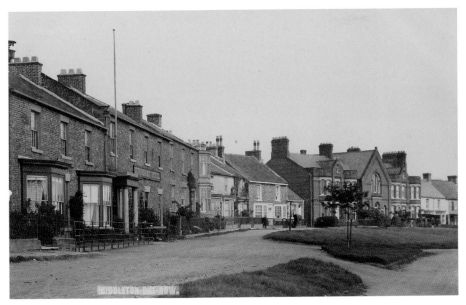

Here in 1906, the Devonport Hotel was already a prominent fixture on The Front at Middleton One Row, as it is today.

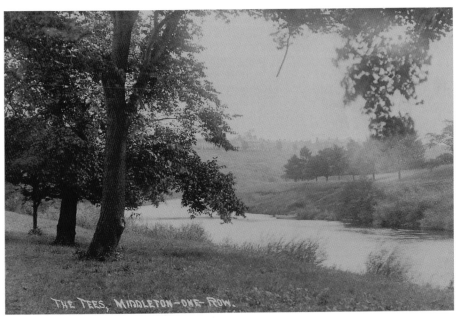

Visible as a faint outline on the horizon is The Front and the buildings of Middleton One Row. This photograph was taken a little further upstream, near Dinsdale Spa.

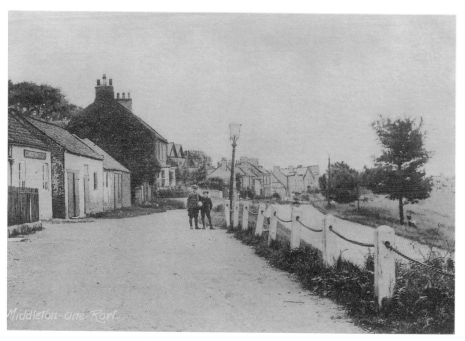

A 1920s view of The Front and two young boys posing for the camera.

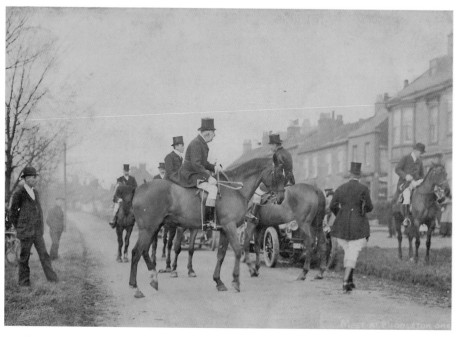

The meet of the hunt in Middleton One Row from a card posted in 1910.

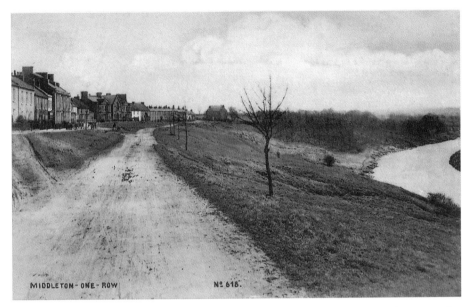

This scene of Middleton One Row in 1910 shows just how open the view of the meander in the River Tees was before the trees grew and later housing developments came along.

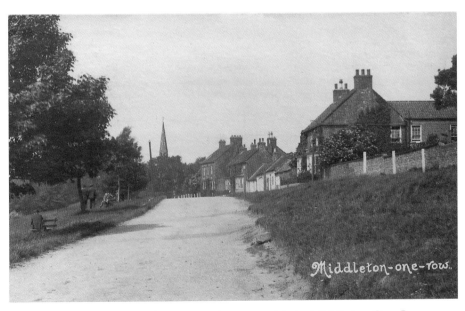

The pleasing view over the river and countryside in Middleton One Row was even attracting visitors to sit and take it all in when this photograph was taken in 1915. The spire in the distance is at St. Laurence's Church.

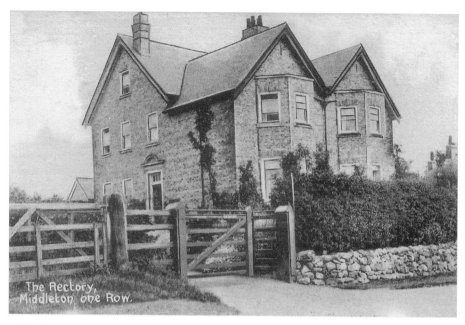

The Rectory serving the vicar of St. Laurence's Church in Middleton One Row.

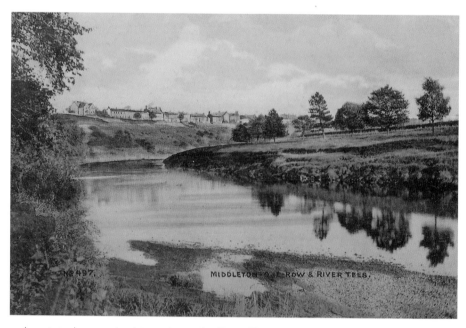

A painted scene looking along the River Tees towards Middleton One Row. The opposite bank leads to the village of Over Dinsdale.

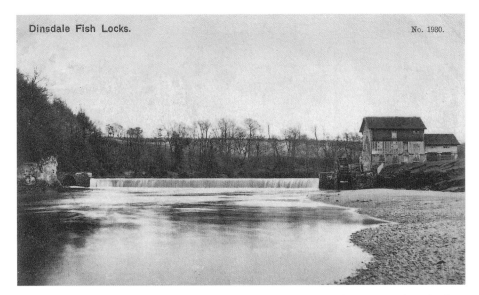

The Dinsdale Fish Locks were put in place on the River Tees beneath today's Dinsdale Golf Club around 1876, with the addition of a weir. A mill also stood on the banks. The locks were removed in the early 1900s.

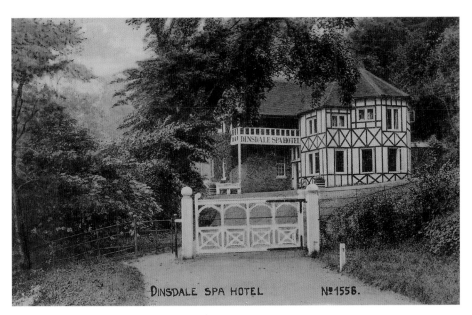

Natural springs were discovered alongside the River Tees near Middleton One Row in the late 1700s and a spa was established there. The Dinsdale Spa Hotel was built in 1829 to cater for the many visitors who travelled there, many using the new Stockton a Darlington Railway.

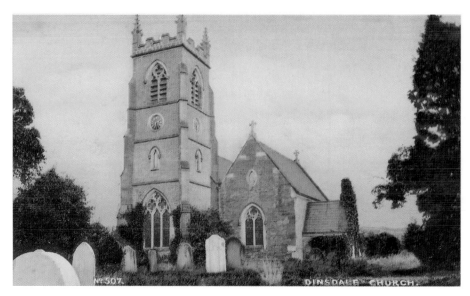

South of Middleton One Row and close to Neasham is the small village of Low Dinsdale, with its red stone church of St. John the Baptist.

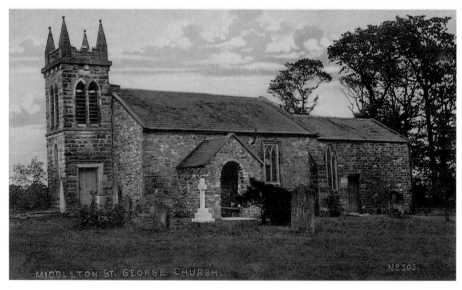

The ancient church of St. George now sits isolated from the villages of Middleton One Row and Middleton St. George, ever since what is now Durham Tees Valley Airport was built during World War II. It was once a place of worship for many local villages and farming communities, including the now deserted village of West Hartlepool. Since this photograph was taken the tower has been removed.

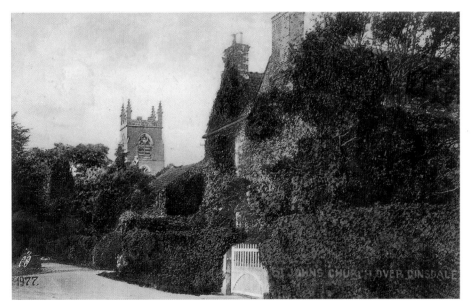

Although this postcard is labelled as Over Dinsdale, it is actually Low Dinsdale, on the County Durham bank of the river. Over Dinsdale is a small hamlet less than a mile away, but in the county of North Yorkshire.

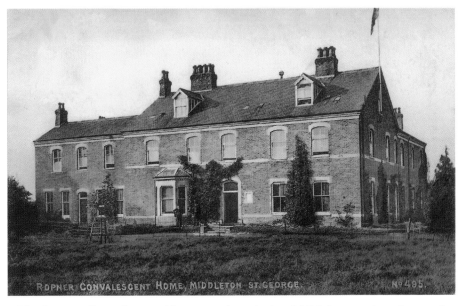

The Ropner Convalescent Home was founded in 1894. It served as a hospital during World War I, and finally closed in 1999. The building has now been converted into private apartments.

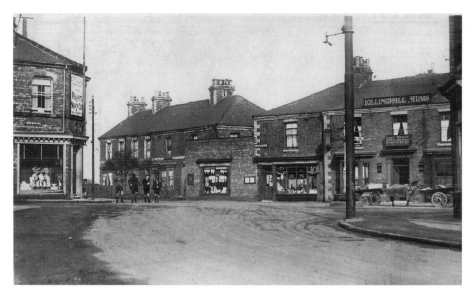

Visitors to Middleton St. George today would recognise the buildings, but not the businesses on The Square. Seen here are the Killinghall Arms, a sweet shop, drapery store and another shop in the building occupied by today's newsagent.

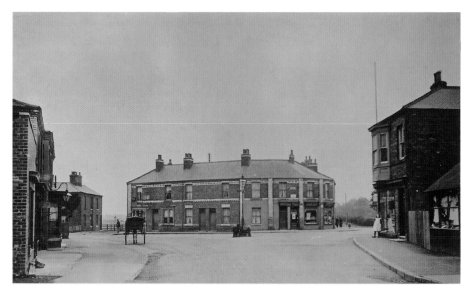

Another view of The Square. The buildings opposite the camera were demolished and replaced by modern houses many years ago. Note the young boys posing for the camera around the lamp post in the centre of the picture.

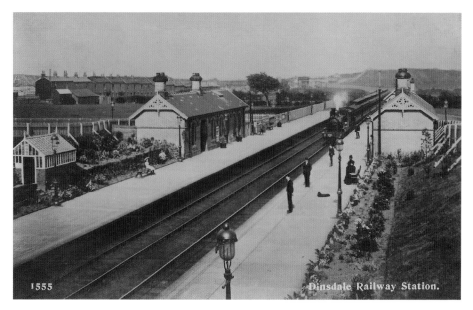

Dinsdale Station in Middleton St. George which opened on the new line through the village. It was named after the nearby Dinsdale Spa, which attracted many visitors to the town by train. The station won awards because of its flower and plant arrangements, which can be seen behind both platforms here.

The Henry Andrew William Cocks Almshouses in Middleton St George.

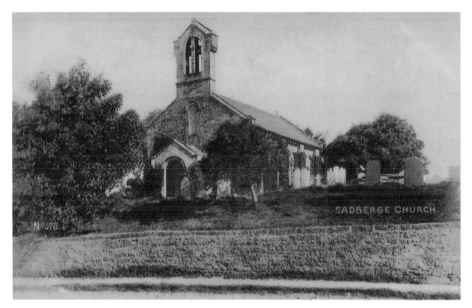

St. Andrew's Church in Sadberge occupied an elevated position over the surrounding houses. It is thought the church sits on the remains of the village's original castle or fortified manor. Evidence of a moat on the eastern boundary can still be seen.

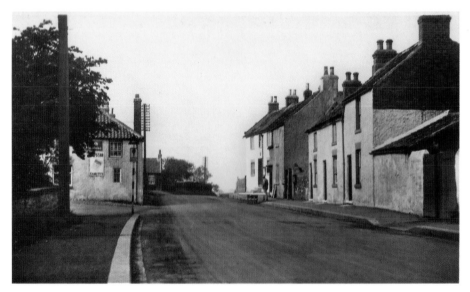

The main road from Darlington to Stockton as it passed through Sadberge. Note the workman outside one house, and the signs for chocolate and cigarettes outside what was once a shop.

ACKNOWLEDGEMENTS

My gratitude to Matt Falcus for his continuing faith in my abilities and his admiration for my extensive postcard collection from which all the images in this book were drawn.

However, I still owe my family a debt of gratitude for their help, encouragement and support in all my postcard collecting, collating and compiling endeavours.

Chief amongst them is my loving sister Shahadh who has been constant in my life with her caring support and as always she is my solid bedrock as well as my loving London nieces and nephews. Not forgetting my many close cousins and their families. Those with Middlesbrough connections include Robeena-Asghar, Saleem, Rubila and Sameena plus Gulshan-Raza and their family.

A big Thank You to my many other nieces and nephews and their wives and families who have always been at the forefront with their enthusiasm for my books. From Middlesbrough, they include Khashif and Fareeha, with Abdullah-Abdul & Rumeesa, plus couples Arfann-Samaira, Adnan-Moqadas & Mehran-Samaira. In addition to the Ahmad-Dinsdale clan which include Sarah-Azim and Atif-Harri plus Zaynah and Adam.

From Leicester, Syma-Saqib plus Hamaira-Faisal (Henly), Samira and Imram in Manchester, as well as Amar and Rizwana in Birmingham. Others in Birmingham include Pra Nisar and his family, in addition to Baji Tabassum and Arfan, plus Asia-Amar and their family. From Leicester, a thank you to all the Afzal and Nurgis family and to my friend and cousin Ejaz, who is, as always, 110 per cent supportive of all that I embark upon.

An extra special mention of my dearest Haq family in Bristol comprising of my lovely Baji Zehra (the founder of DHEK BHAL women's group), Bhai Ikramul Haq, Nabeel and Azmeena.

As with my family there are so many friends here in the UK who have encouraged and aided me in my postcard collecting over many years. Going back some 40 years Katrina and (sadly the late) Phillip Bunn have always encouraged and supported me on my postcard quests. As have others, like close friends Coleen Jennings, George and Barbara Reid plus Gully, Ibi and more recently Sohaib Afzal.

Last but not least a big Thank You to all my fellow collectors who have become good friends such as Sue Martin (founder of Memories of Middlesbrough) Carol and Martin Ingledew, and especially James Beadle who has been very

helpful, supportive and kind in the sharing of many images from his impressive collection.

Close friends who have always been supportive even from abroad include my (Otherforce and Feelay) Kyriakos and Natalie Timotheou with Loucas and Harrys, my Cypriat "family" in Nicosia. Also in Cyprus is my loving and caring niece Jacqueline and husband (Khoolas) Kyriakos who have always

"Been there for me" whenever help was needed, always, ready and willing no matter what it was for. In Washington DC lives my very kind friend and "brother" Ravi Kakudia who has been an inspiration second to none. Together with my Nephew Khurrum in LA and Thairee and the Mahmood Clan in Texas they comprise my faithful, friendly and fantastic family in America.

In Italy my Welsh-Roman friend and "brother" Gian Piero Malnati (Bambino) has never wavered in his faith in my postcard collecting and compilation in books such as this. Flavia, Lucio and Ulin Nafeesa also resident in Rome, together with my many friends and family from the USA, Greece, Singapore and Malaysia are not forgotten.

In Pakistan family are no less supportive with cousins in Lahore such as Pra's Saeed, Ruccka and Billa amongst so many others.

A special mention of my cousin Riaz and my late Bhabi Uzzra who was always looking out for me on all my visits - a wonderful and loving cousin who I will miss greatly. Also recently passed on, my very close and loving cousin from Gujranwala Shaukat who was not just family but was also my friend.

To ALL who have all taken a keen and supportive interest in my historical postcard endeavours, and to everyone else I have been unable to mention mentioned here - I thank you all.